THE
FOX
AND
THE
STAR

PENGUIN BOOKS

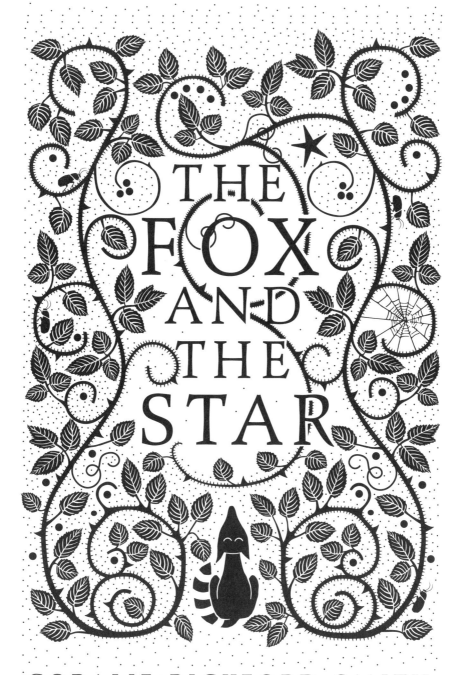

THE FOX AND THE STAR

CORALIE BICKFORD-SMITH

A
for
Abigail

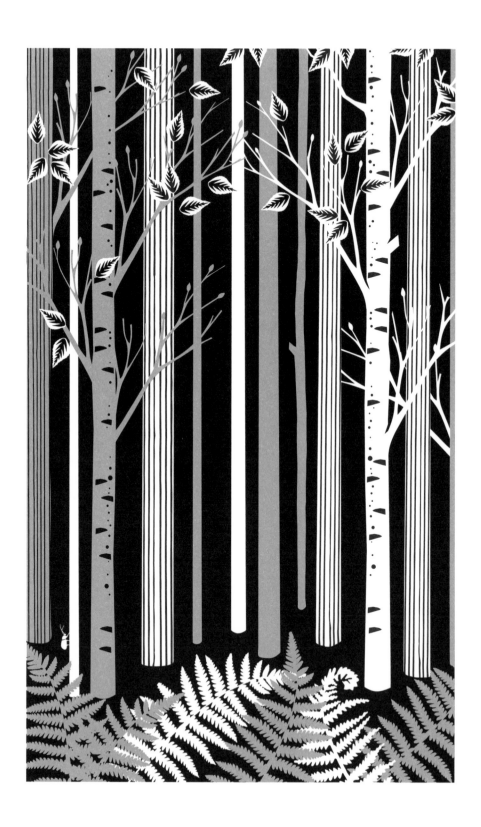

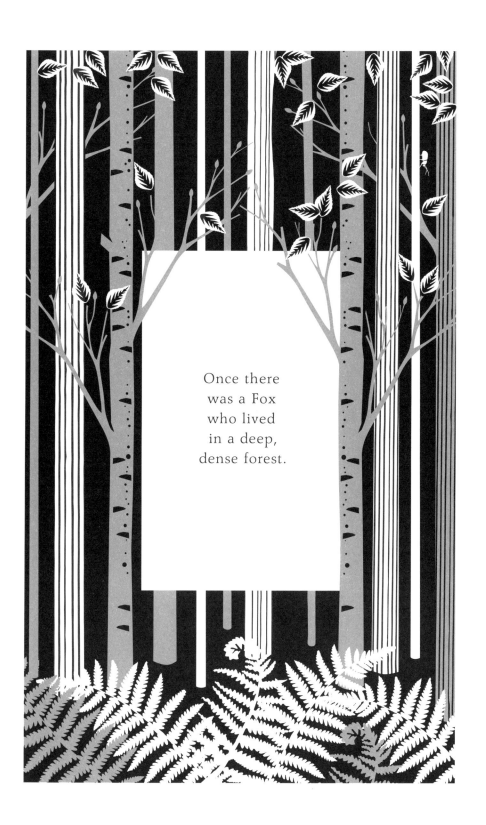

Once there
was a Fox
who lived
in a deep,
dense forest.

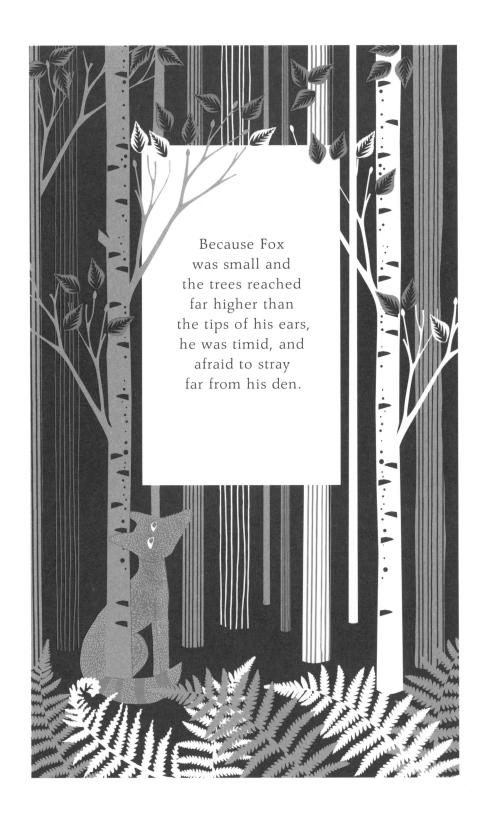

Because Fox
was small and
the trees reached
far higher than
the tips of his ears,
he was timid, and
afraid to stray
far from his den.

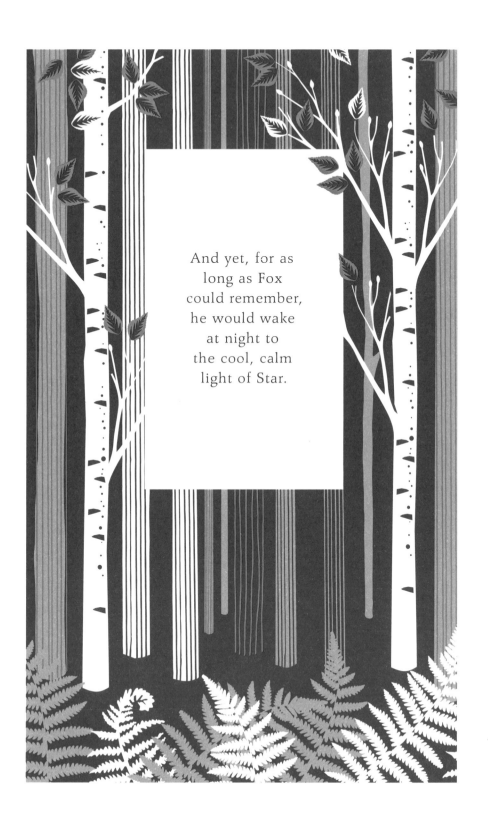

And yet, for as
long as Fox
could remember,
he would wake
at night to
the cool, calm
light of Star.

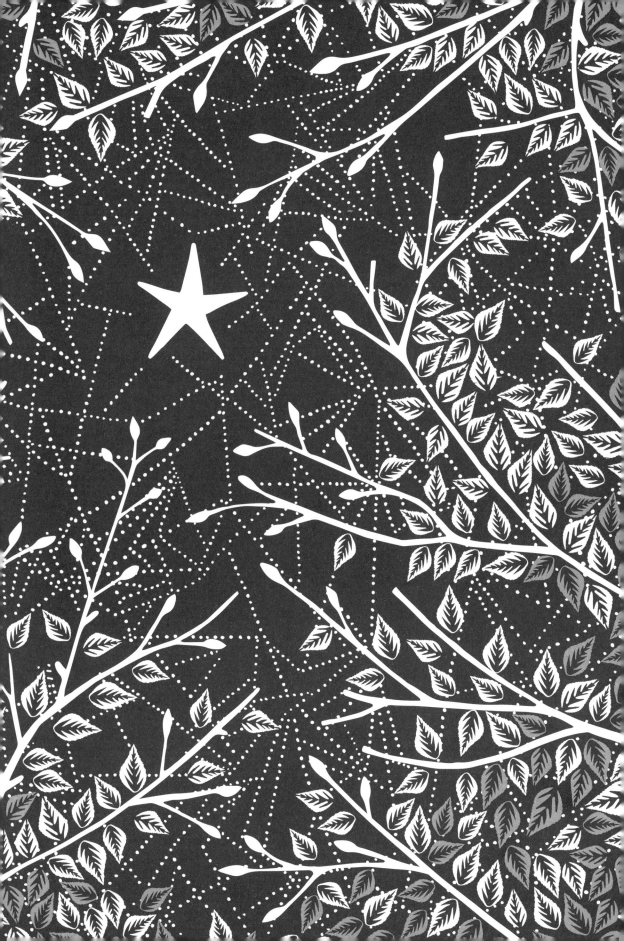

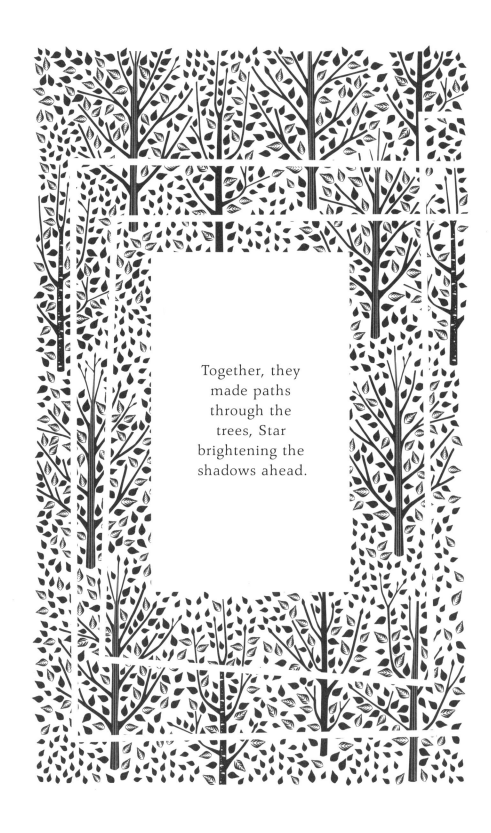

Together, they
made paths
through the
trees, Star
brightening the
shadows ahead.

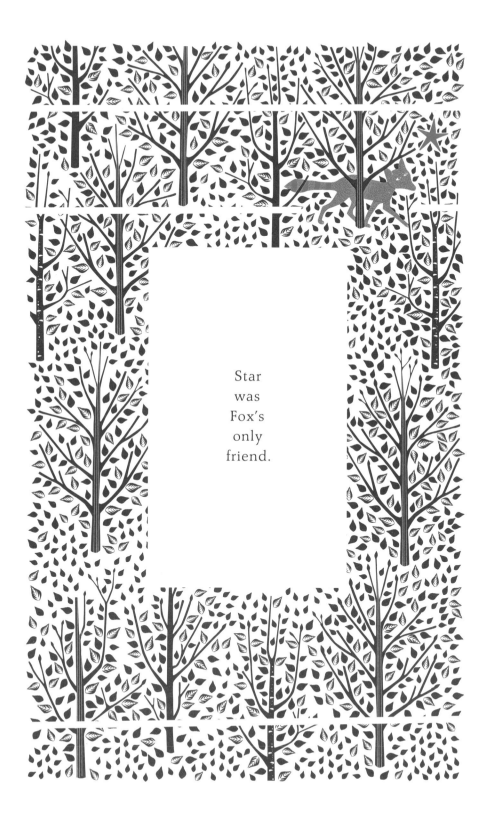

Star
was
Fox's
only
friend.

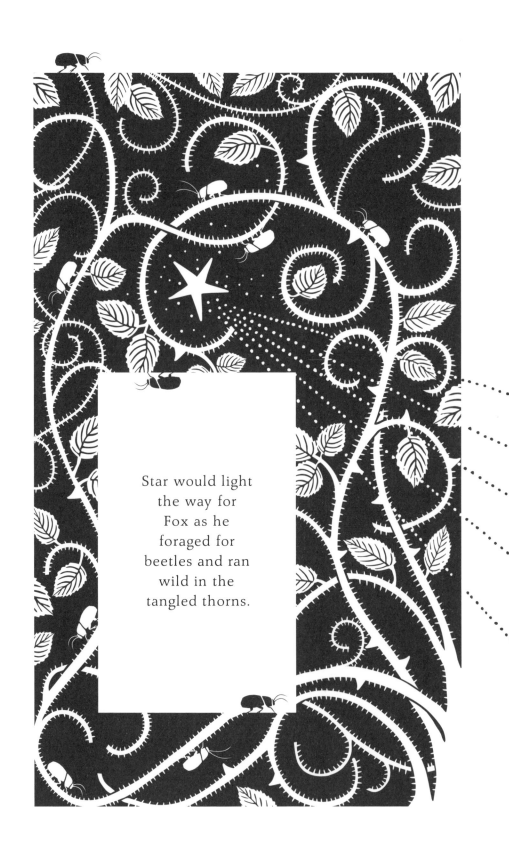

Star would light
the way for
Fox as he
foraged for
beetles and ran
wild in the
tangled thorns.

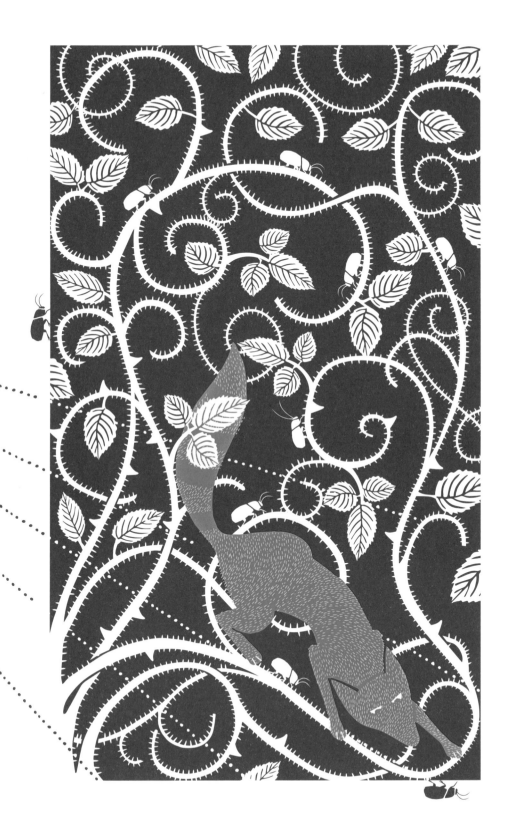

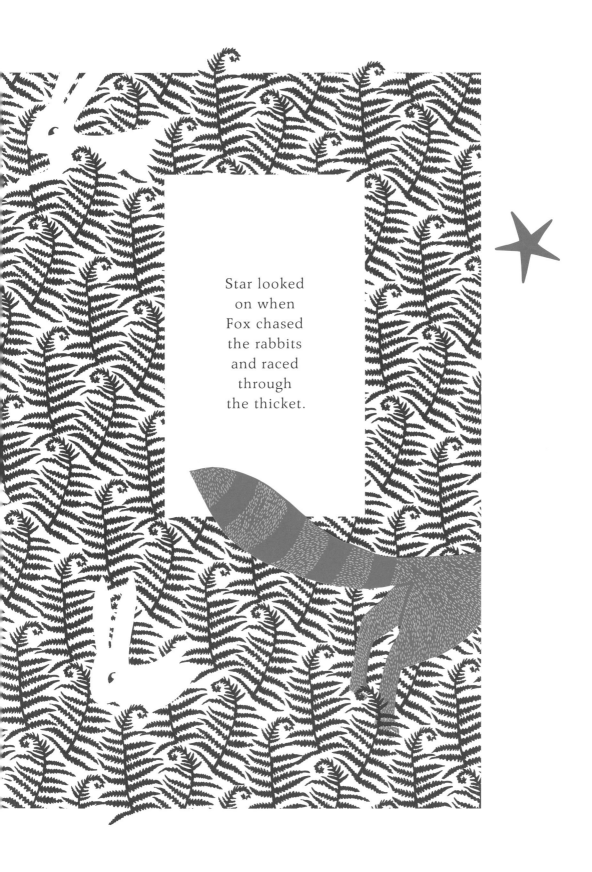

Star looked
on when
Fox chased
the rabbits
and raced
through
the thicket.

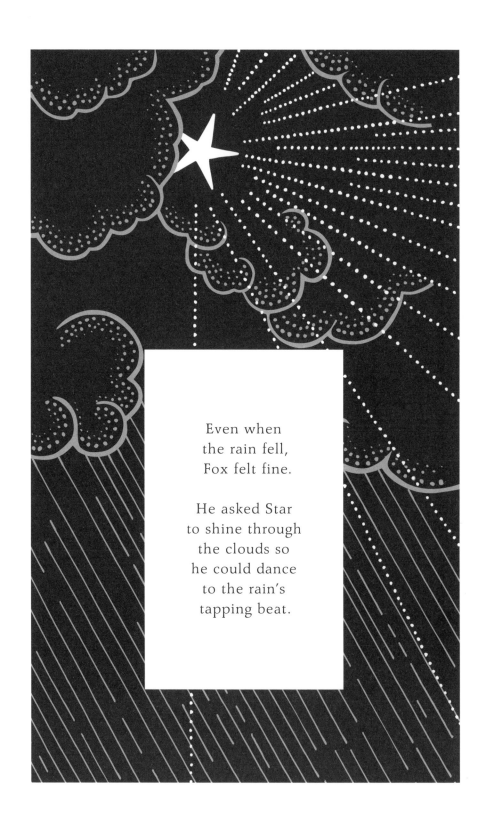

Even when
the rain fell,
Fox felt fine.

He asked Star
to shine through
the clouds so
he could dance
to the rain's
tapping beat.

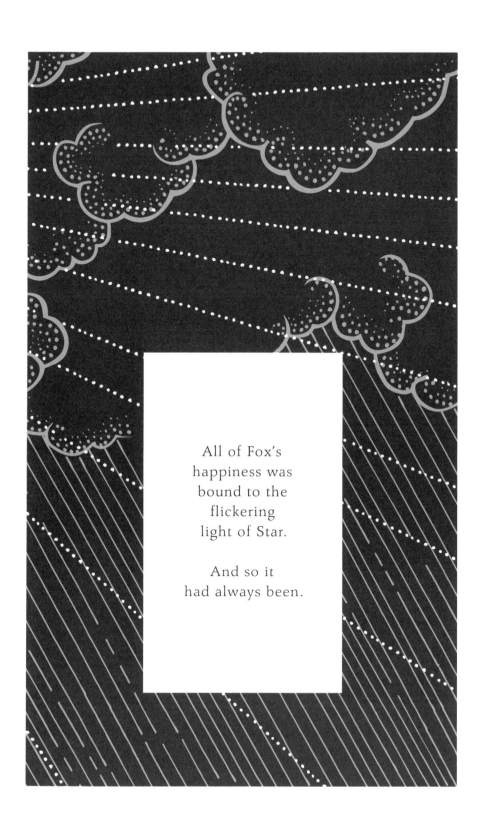

All of Fox's
happiness was
bound to the
flickering
light of Star.

And so it
had always been.

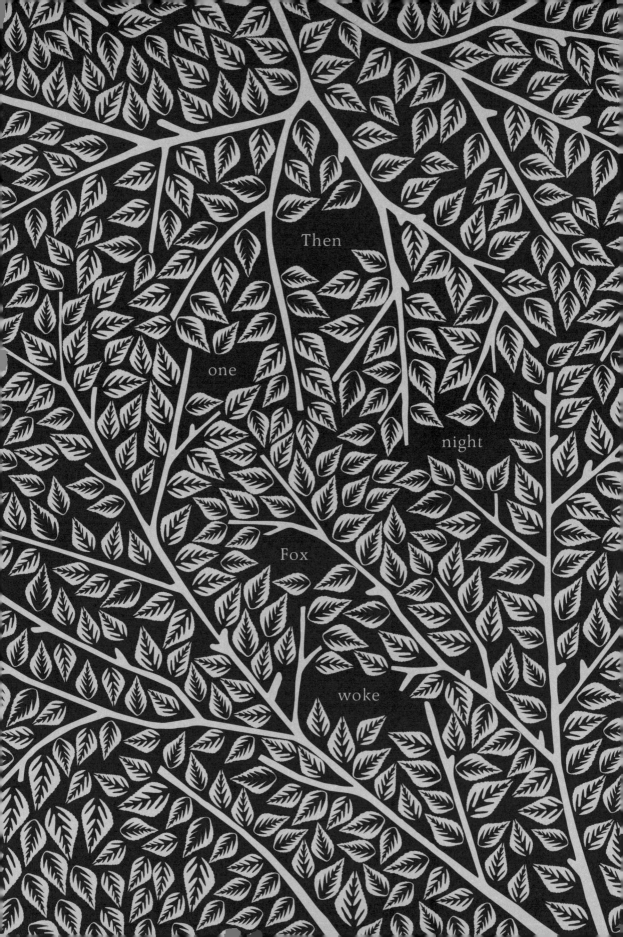

Then

one

night

Fox

woke

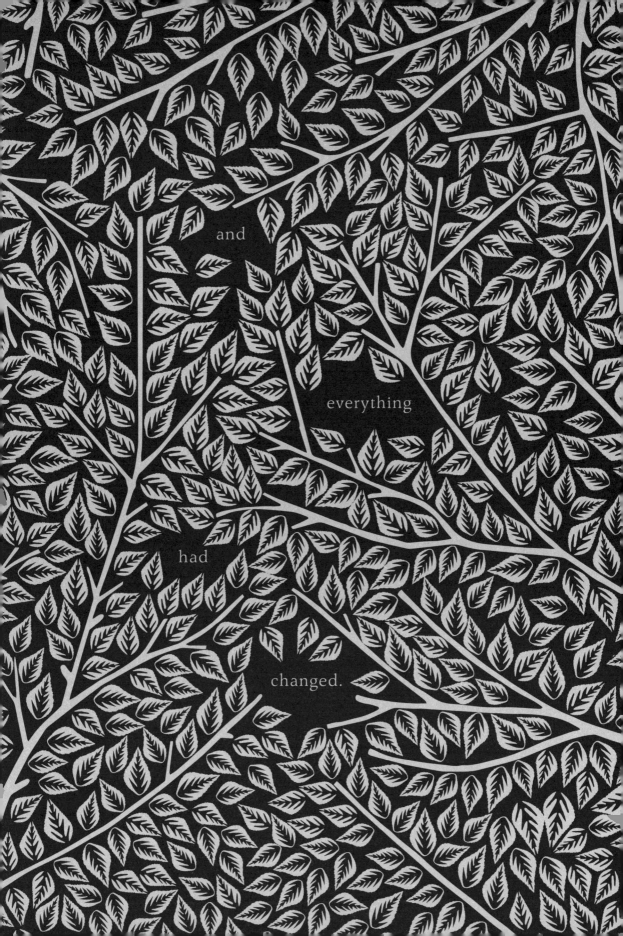

and

everything

had

changed.

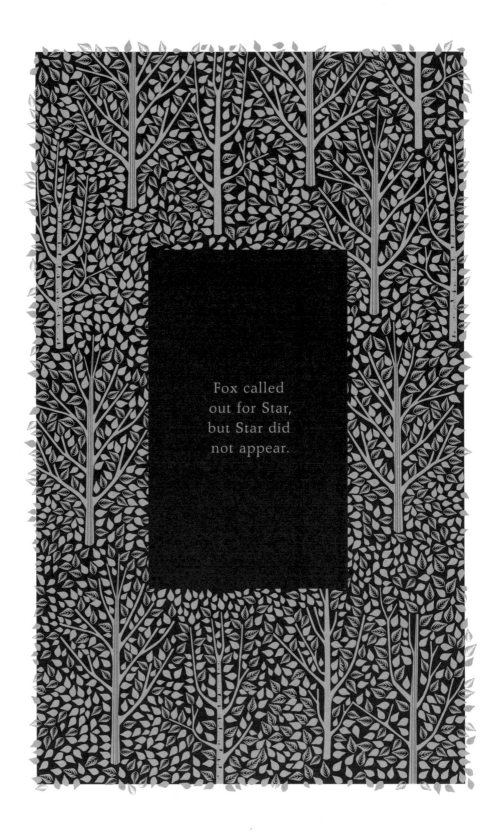

Fox called
out for Star,
but Star did
not appear.

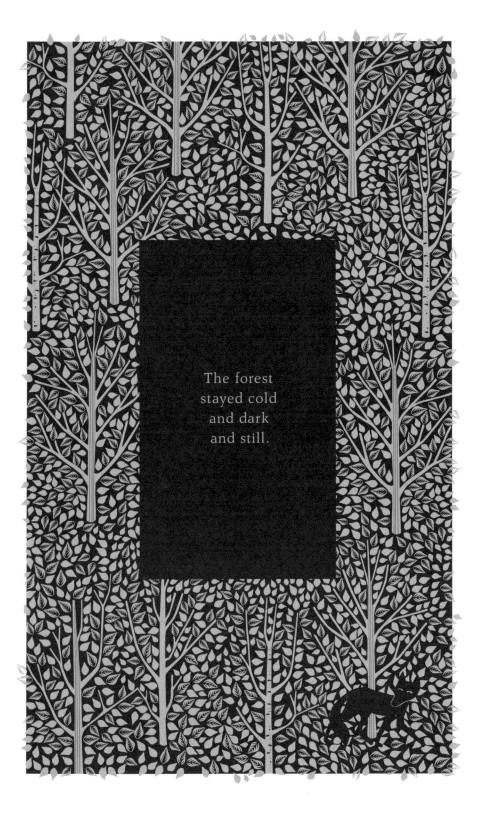

The forest
stayed cold
and dark
and still.

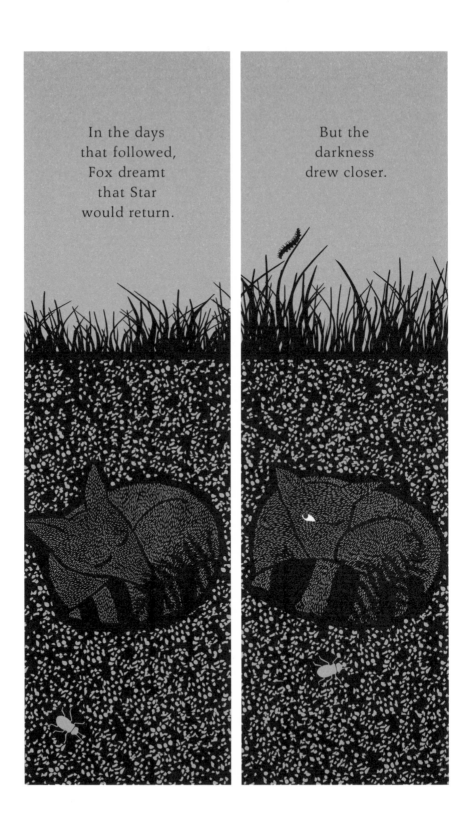

In the days
that followed,
Fox dreamt
that Star
would return.

But the
darkness
drew closer.

Without Star,
there was no
reason to
go outside.

Worried
and lonely,
he huddled
in his den.

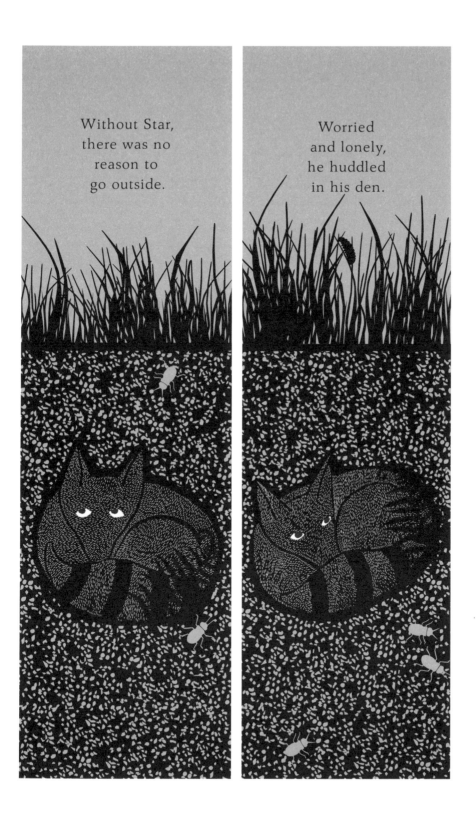

Days and nights
passed in silence,
until something
stirred in the forest.

The beetles
were on the
move, creeping
and crawling
to where Fox lay.

Closer

beetles

and

the

came,

closer

seeking

the

still

body

of

Fox his den.

of

in

the belly

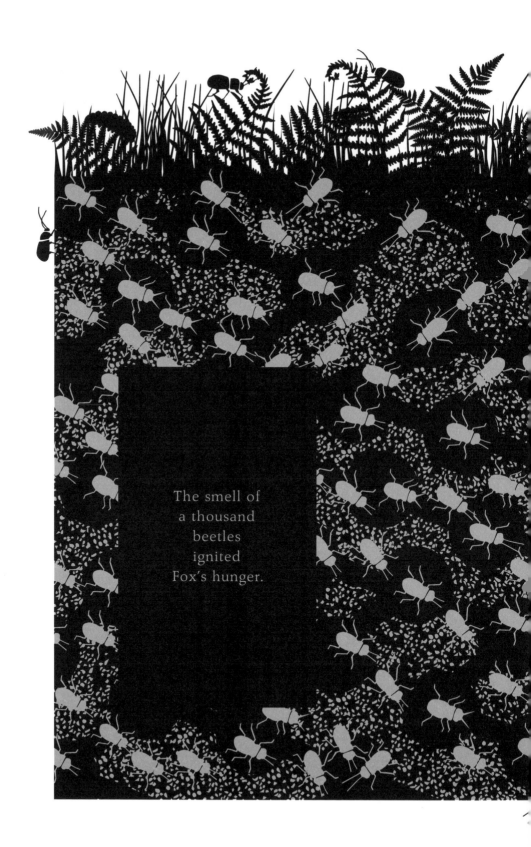

The smell of
a thousand
beetles
ignited
Fox's hunger.

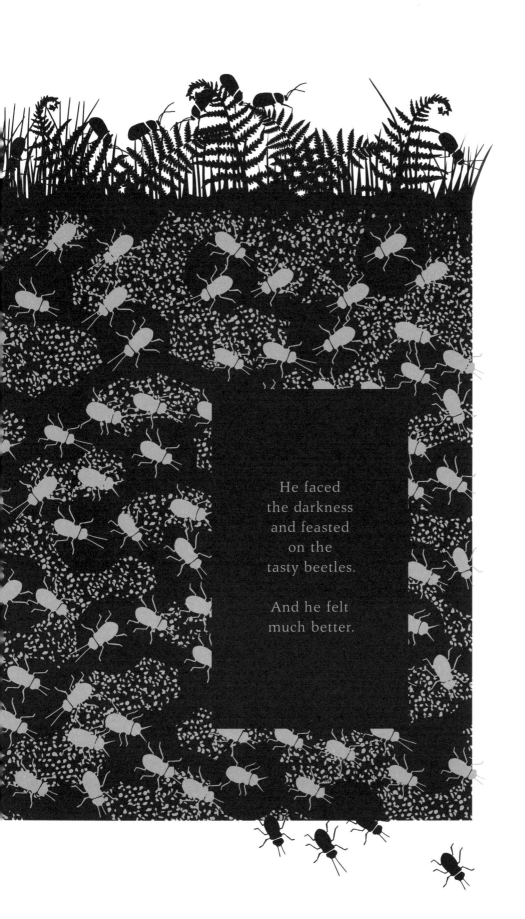

He faced
the darkness
and feasted
on the
tasty beetles.

And he felt
much better.

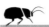

It was
time to
go and
find Star.

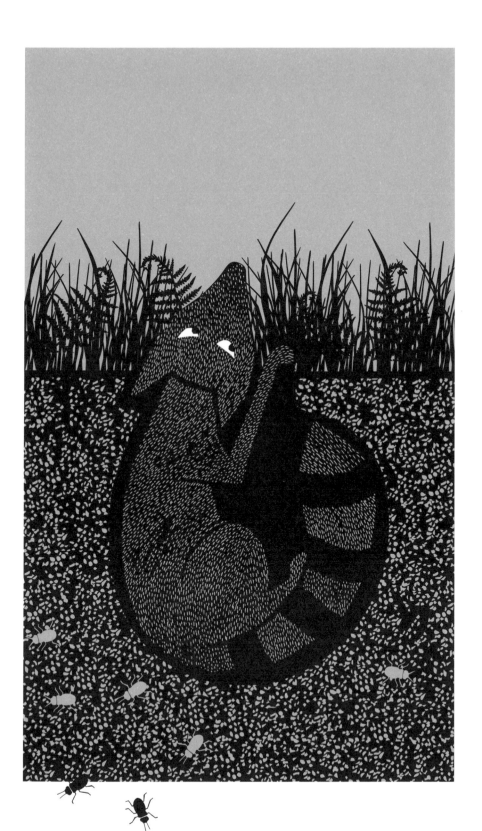

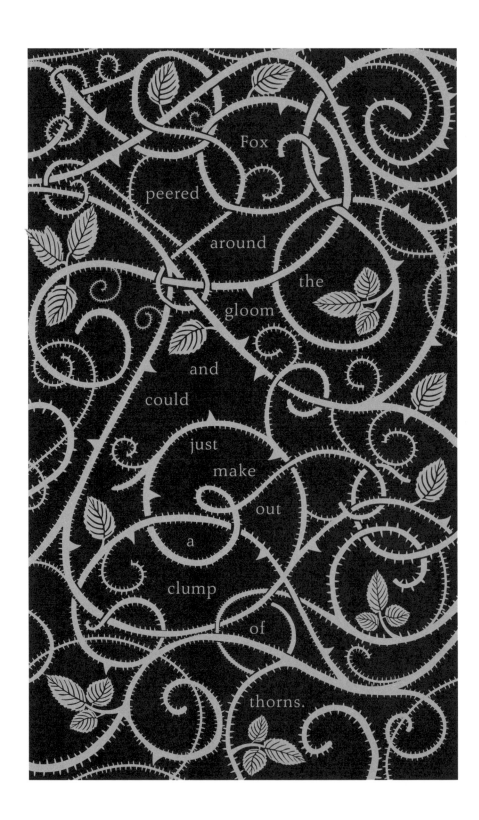

Fox peered around the gloom and could just make out a clump of thorns.

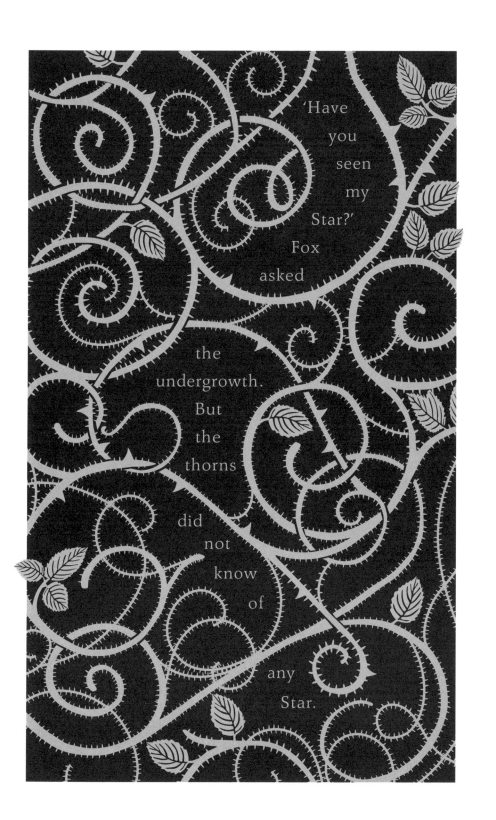

'Have
you
seen
my
Star?'
Fox
asked

the
undergrowth.
But
the
thorns

did
not
know
of

any
Star.

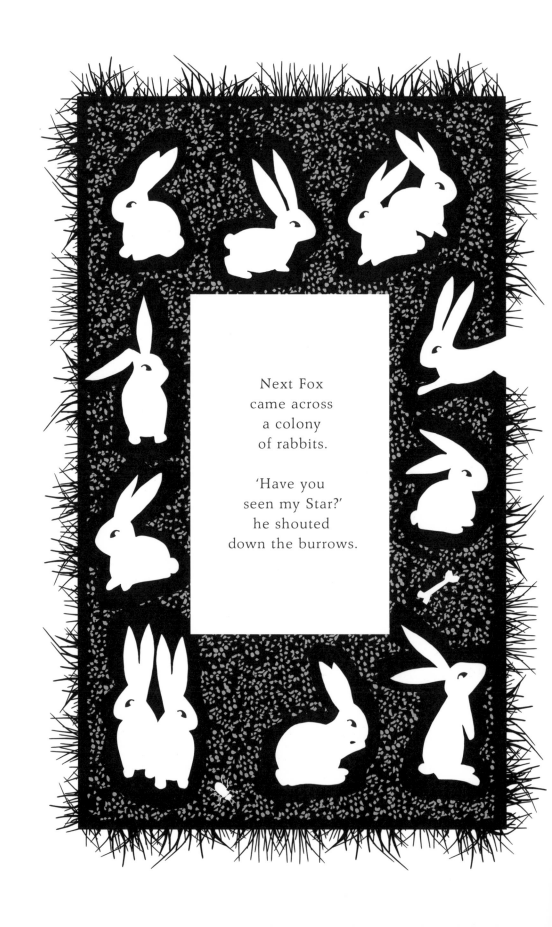

Next Fox
came across
a colony
of rabbits.

'Have you
seen my Star?'
he shouted
down the burrows.

But
rabbits
have
no
time
for
foxes.

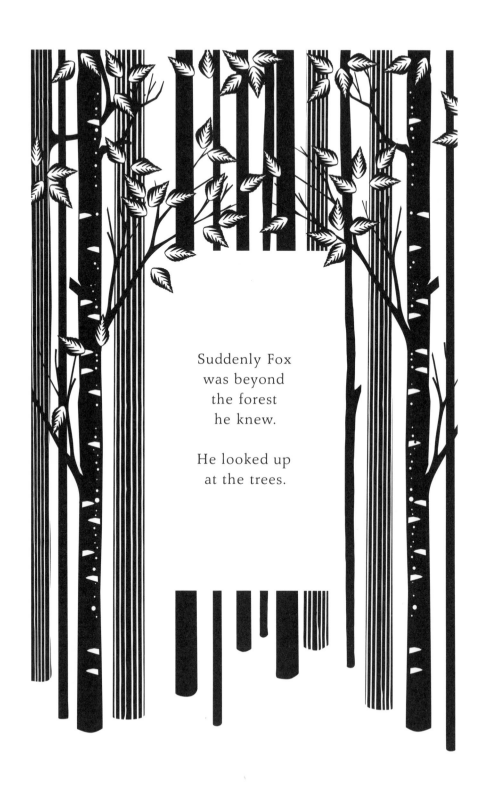

Suddenly Fox
was beyond
the forest
he knew.

He looked up
at the trees.

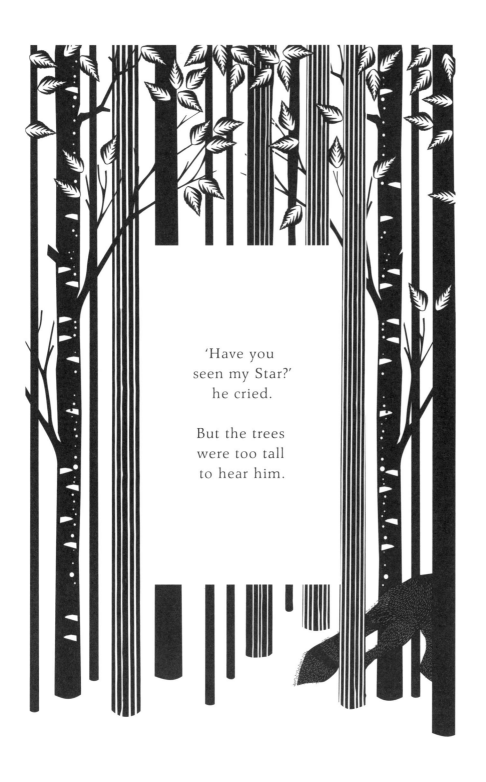

'Have you
seen my Star?'
he cried.

But the trees
were too tall
to hear him.

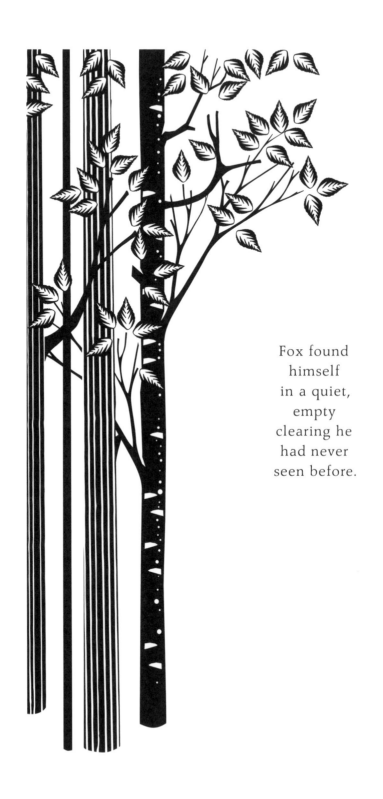

Fox found
himself
in a quiet,
empty
clearing he
had never
seen before.

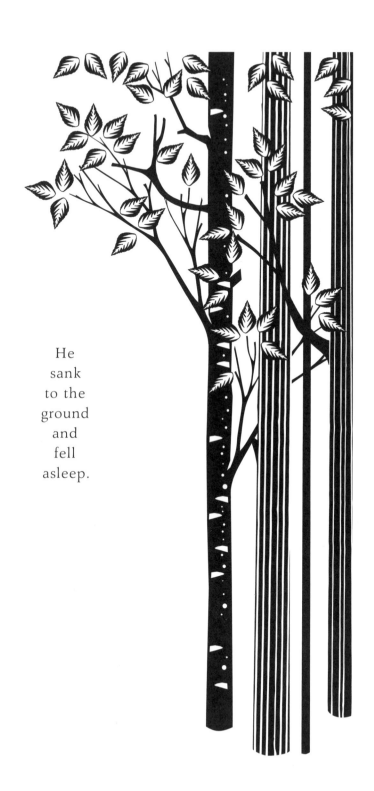

He
sank
to the
ground
and
fell
asleep.

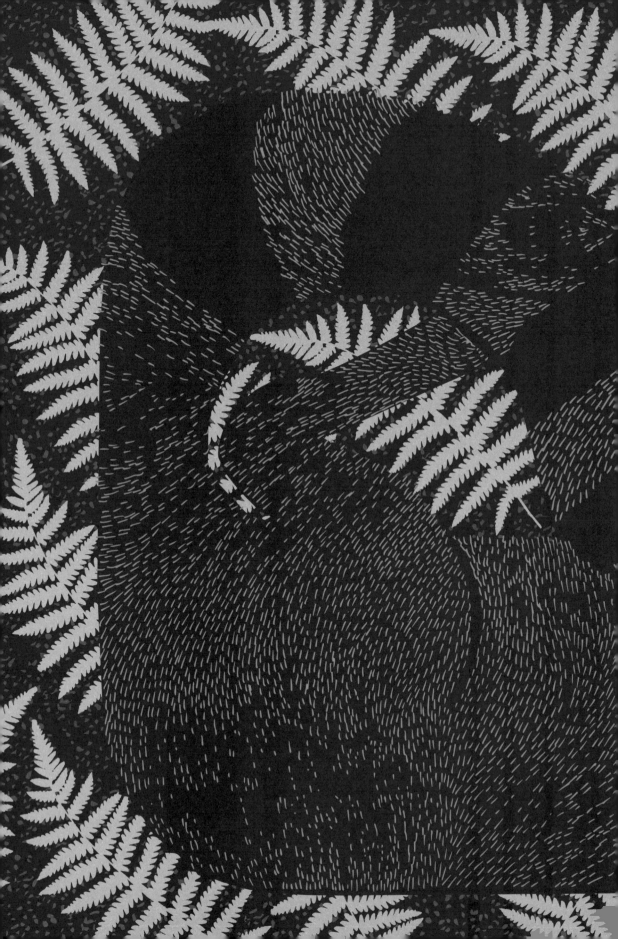

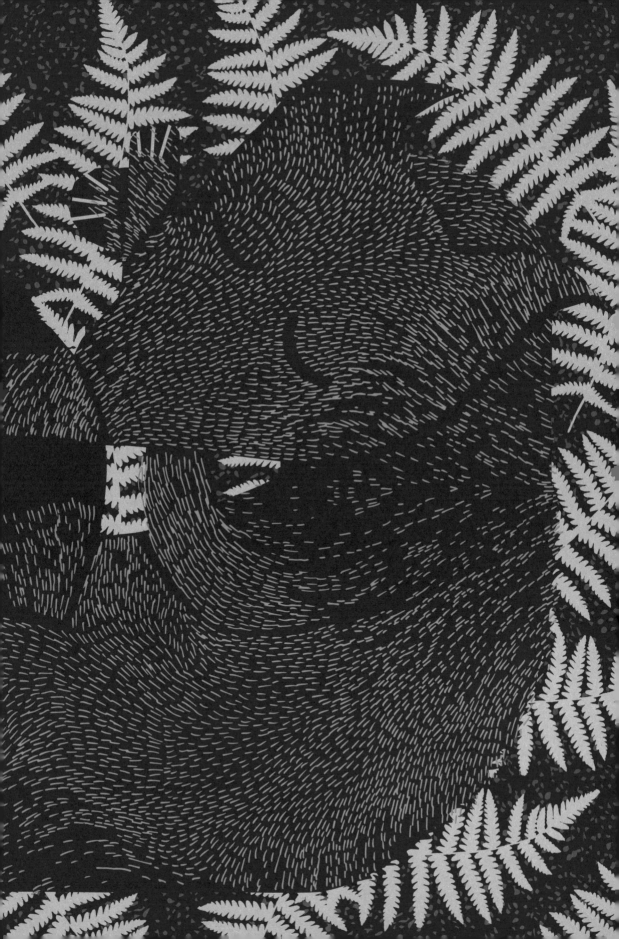

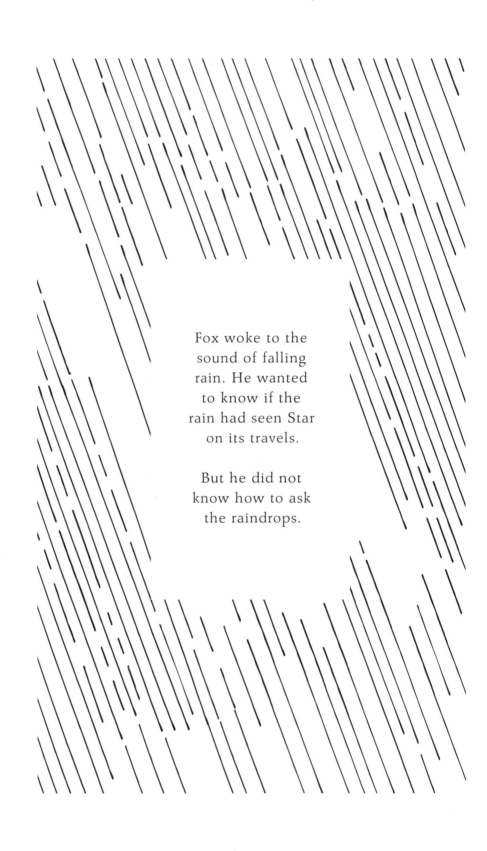

Fox woke to the
sound of falling
rain. He wanted
to know if the
rain had seen Star
on its travels.

But he did not
know how to ask
the raindrops.

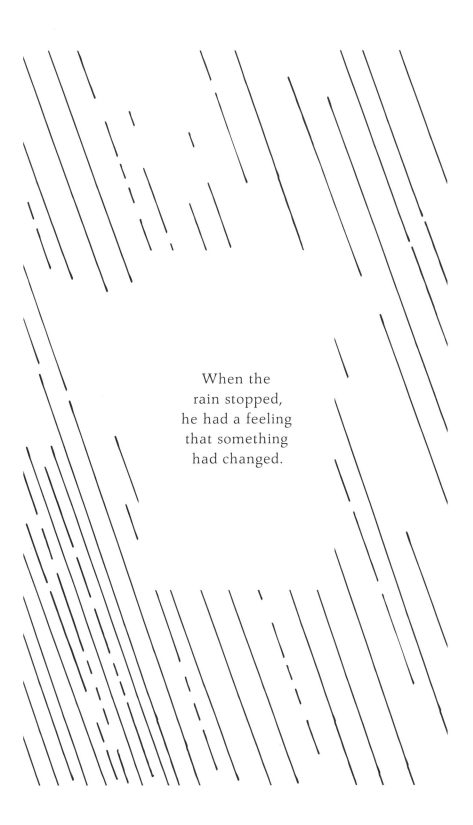

When the
rain stopped,
he had a feeling
that something
had changed.

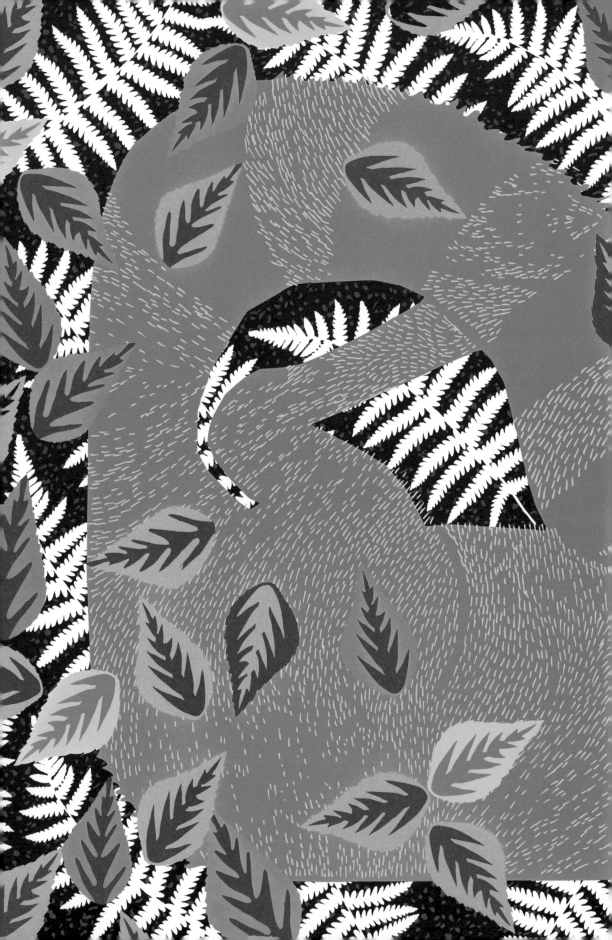

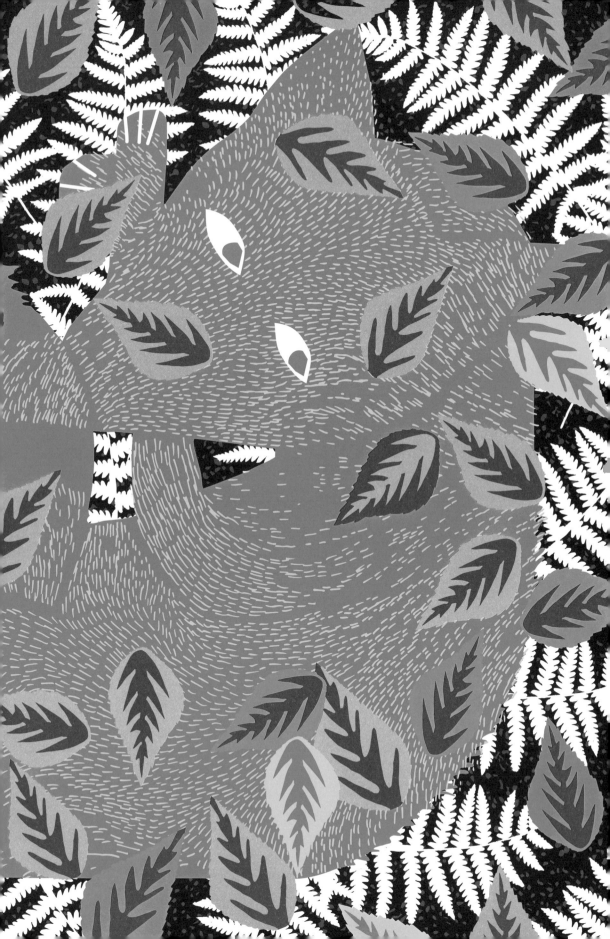

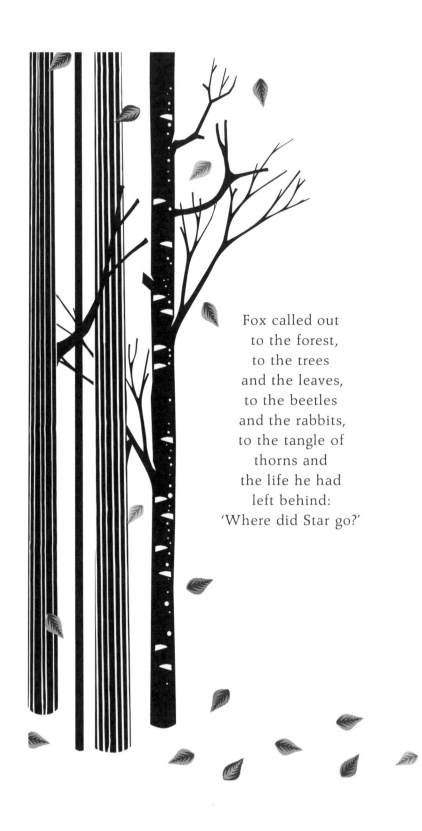

Fox called out
to the forest,
to the trees
and the leaves,
to the beetles
and the rabbits,
to the tangle of
thorns and
the life he had
left behind:
'Where did Star go?'

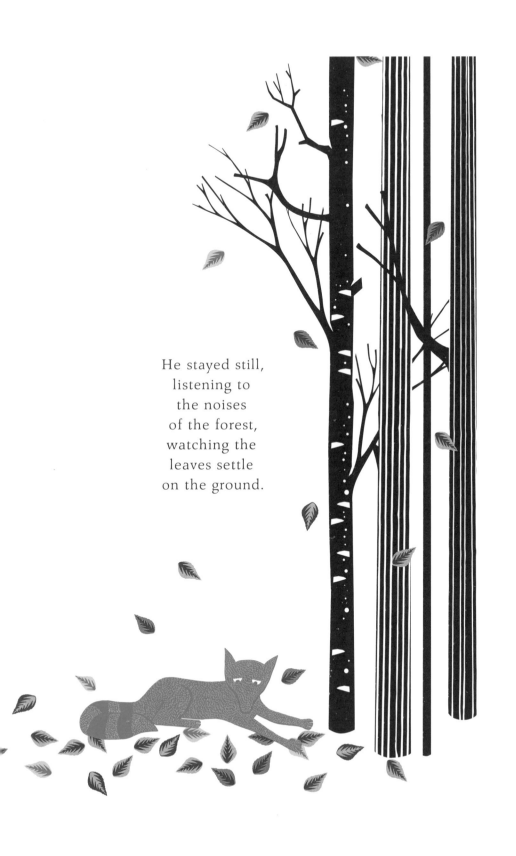

He stayed still,
listening to
the noises
of the forest,
watching the
leaves settle
on the ground.

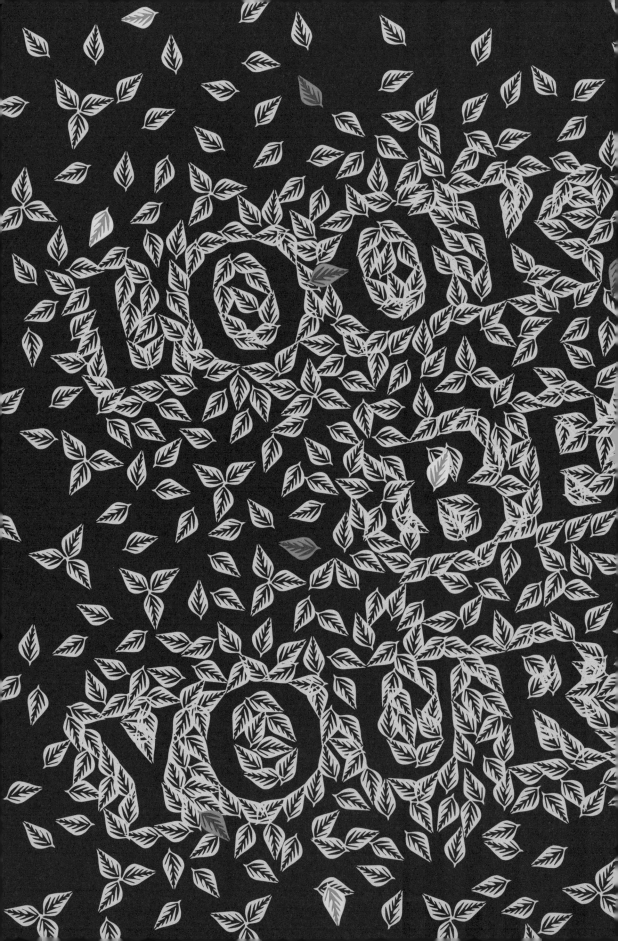

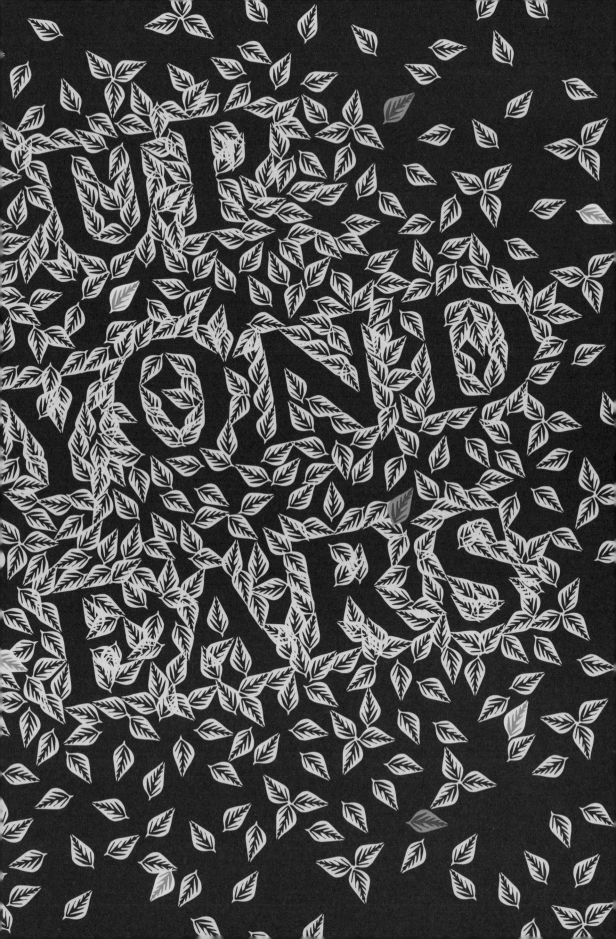

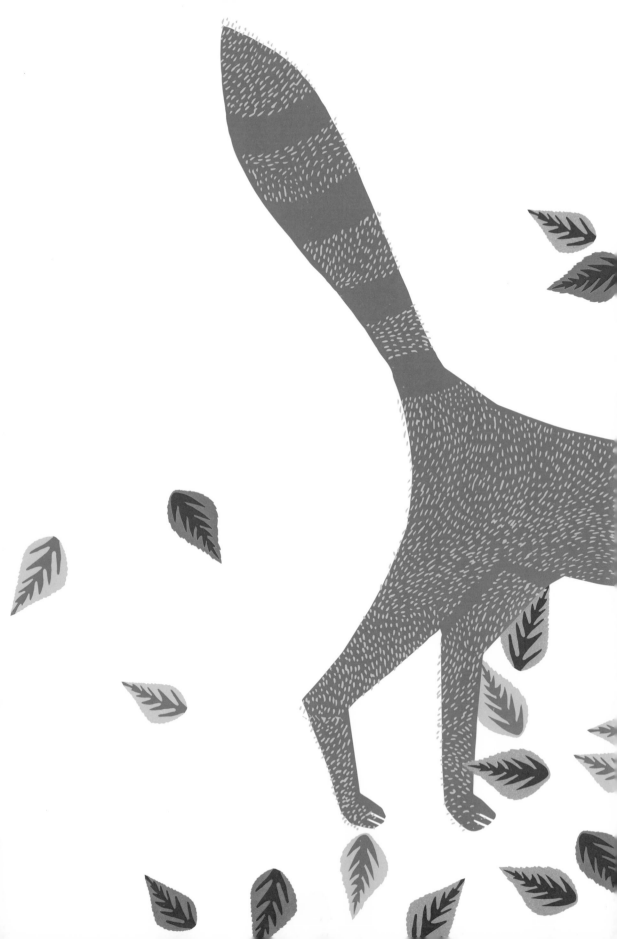

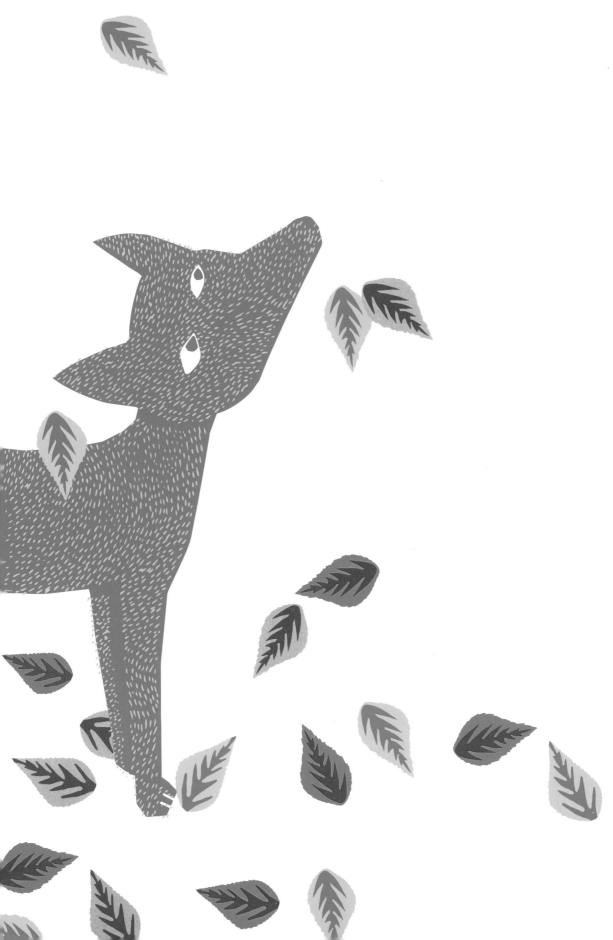

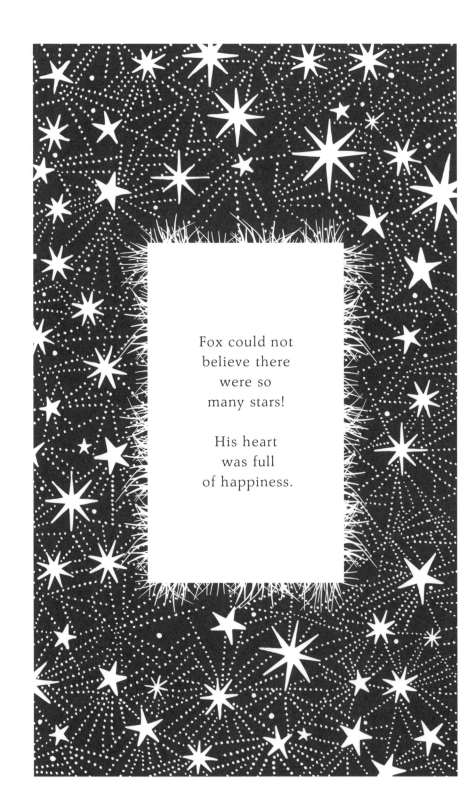

Fox could not
believe there
were so
many stars!

His heart
was full
of happiness.

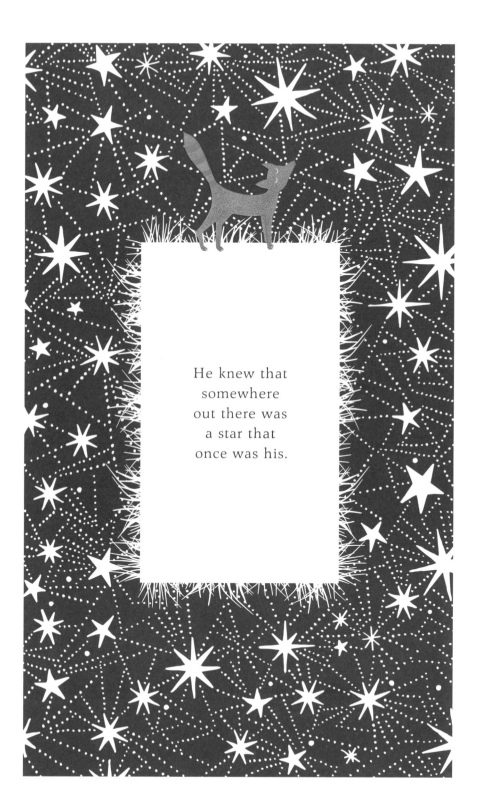

He knew that
somewhere
out there was
a star that
once was his.

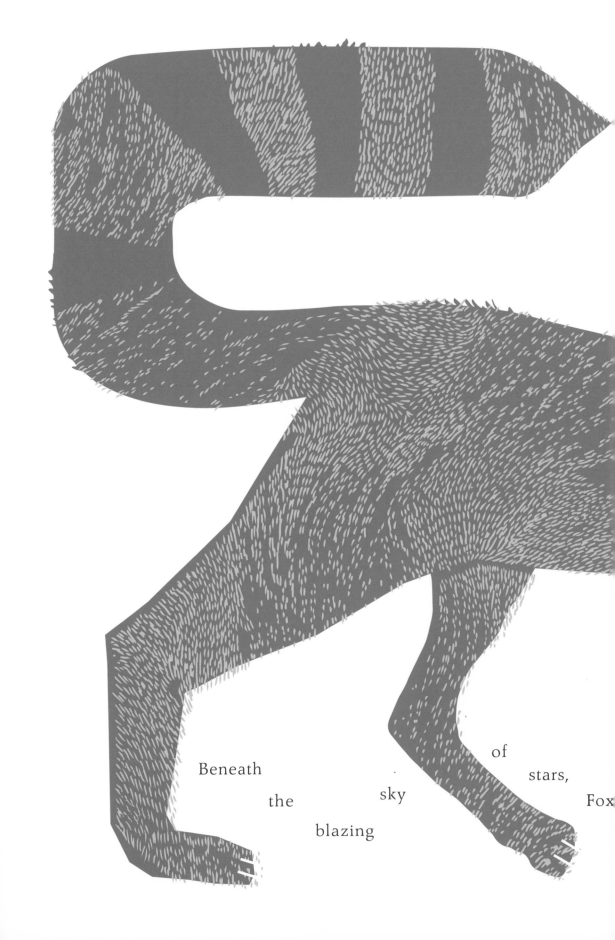

Beneath the blazing sky of stars, Fox

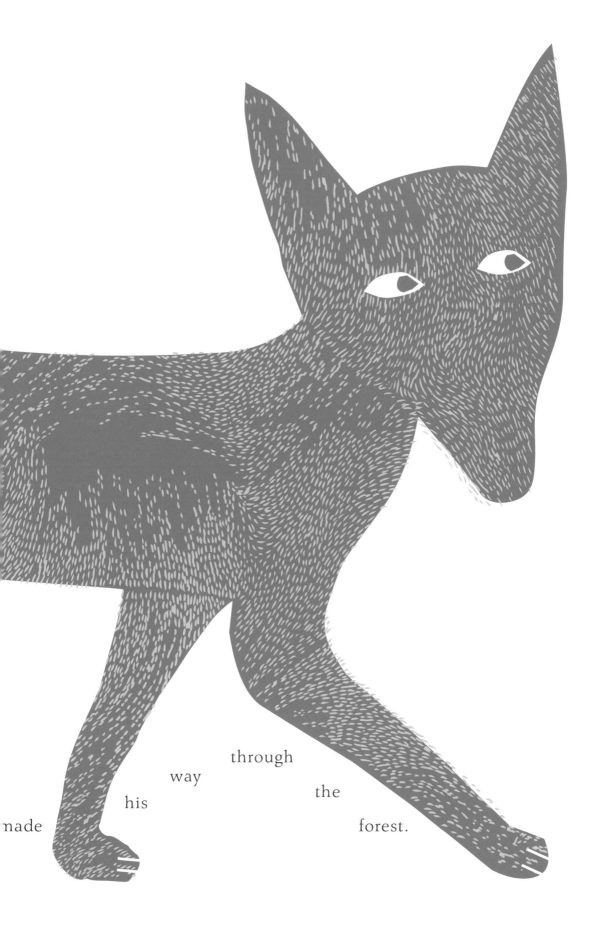

made his way through the forest.

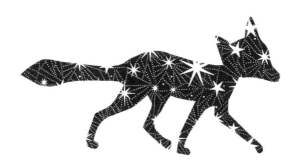

PENGUIN BOOKS

An imprint of Penguin Random House LLC
New York, New York 10014
PENGUIN BOOKS
375 Hudson Street
penguin.com

First published 2015

ISBN 978-0-14-310867-2

Set in Agfa Wile 12pt/15pt by Coralie Bickford-Smith

Printed in Italy by Graphicom Srl on Munken Pure Rough

3 5 7 9 10 8 6 4

Thank you
Helen Conford,
Cecilia Stein,
David
Mackintosh,
and
The Lehmans.